Buildings
with Gene Franks

Learning the basics of pencil drawing is not only enjoyable in and of itself, it will also give you an excellent foundation for working in all other artistic media. And some of the most fascinating subjects to draw in pencil are buildings. With their interesting shapes and varied textures, the architectural delights of the world provide an endless array of unique and pleasing forms to capture. In this book, you'll learn Gene Franks' simple four-step method for drawing a variety of buildings in pencil—from houses and barns to churches and cottages. He explains how to select and choose the correct drawing materials and how to use various pencil points and basic strokes in easy-to-follow lessons. Then he demonstrates simple approaches to shading, such as layering values and adding highlights, to give all your pencil drawings a sense of depth and realism.

Walter Foster

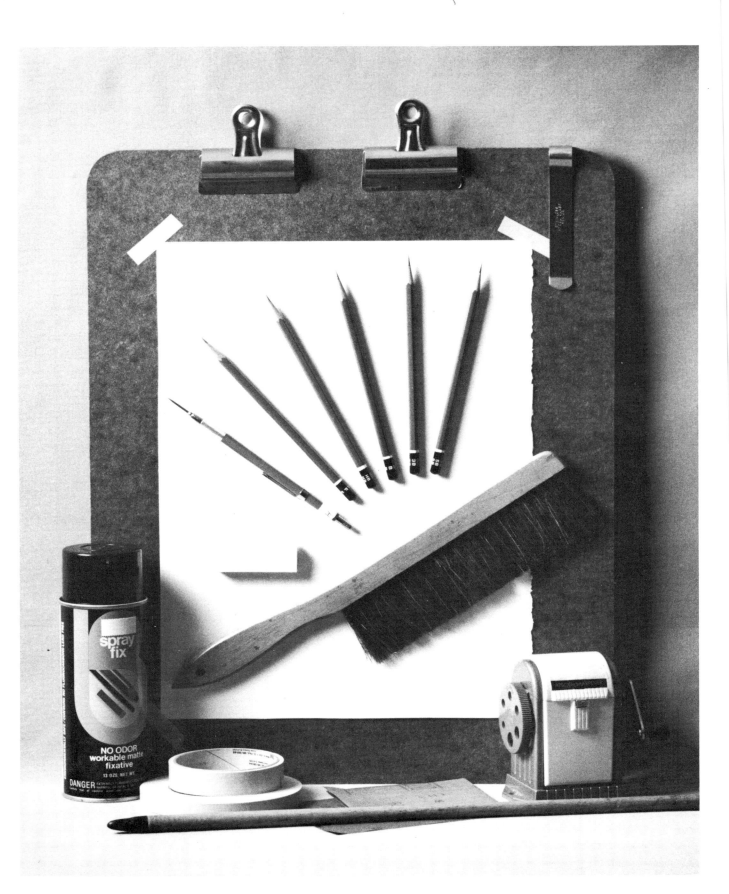

SUPPLIES NEEDED

PENCILS

I use both wooden pencils and metal drafting pencils in this book. The ones I recommend to begin with are:

Wooden Pencils

Hard ⟵ F HB B 3B 5B ⟶ Soft

Drafting Pencil

Metal holder and H lead, for roughing in.

PAPER

I prefer a smooth, textureless paper because I can avoid grain and build my own texture. I use 50% cotton, Italian, 140 lb., neutral pH, hot-pressed paper available in 22" x 30" sheets. Plate finish papers sold in pads are also acceptable.

ACCESSORIES

A smooth **drawing board** of ¼" tempered masonite or plexiglass, size 16" x 20"; **masking tape** or **clips** for attaching paper to your board; a **vinyl eraser** (I use vinyl exclusively to avoid damaging the paper); **maulstick**; sheet of **plain bond paper** to slip under the hand while working to avoid smudging; **desk broom**, to brush off debris; **pencil sharpener**, as pictured; **#220 and #600 sandpaper** for forming lead points; **workable fixative**, available in a spray can. Several light coats are sprayed on the finished drawing to prevent smudging.

PENCIL PROCEDURE

INTRODUCTION

Once you are acquainted with the tools and how to prepare and maintain them, and have practiced the value scale, the pencil strokes, and the shading samples on the following pages, then you are ready to begin the four steps that lead to accomplished pencil drawings. You will need to spend considerable time practicing each step. This faithful practice will bring great results in your final drawings. So plant your feet firmly and dig in for a determined effort in mastering this self-development program of pencil drawing.

STEP ONE — ROUGHING IN

Rough in the subject with an "H" lead and metal holder; the holder laid flat and held under your hand. Allow lots of freedom in your strokes, moving your entire arm. At this point think only about general shapes. You will add definition and detail later. Practice this step again and again.

STEP TWO — LINE DRAWING

You will need to invest time and practice to develop an expressive line drawing. Use the point of an "H" or "F" lead or wooden pencil.* Experiment with holding the instrument in both writing and underhand positions. In the underhand position, you can vary the thickness of your line by rolling the lead or pencil on its side for thick lines or up on the point for thin. Train yourself to show roundness and depth with expressive lines.

STEP THREE — PRELIMINARY SHADING

To achieve successful shading you must establish the structural pattern smoothly and under careful control. Gently "lay in" the darks and shadows in medium tones. Don't commit yourself too darkly, too soon. Once you are sure, darken these areas by pressing harder or switching to a softer pencil. Allow the point to become slick and smooth for even tones.

STEP FOUR — FINISH

For final shading, use a somewhat darker pencil, drawing on a smooth point for even tonal control. Repeat the shading process over and over with softer pencils until you achieve your desired density. Reinforce the lines and accents as you go. Add final action strokes for the ultimate artistic effect.

Focus your attention on each finished drawing in this book, observing the detail, and use the other steps only for reference. Afterwards, concentrate on your own personal handling of the pencil.

To avoid smudging, spray the completed drawing with several light coats of workable fixative. (If you immediately frame the drawing under glass, you do not need to spray.)

Sometimes you may want to create a complete drawing using only one hardness of pencil. "HB" is a good average pencil for this purpose. You may want to start with three HB pencils, one at each degree of sharpness. By varying the pressure on the pencil points and changing hand positions, you can accomplish several values and a wide variety of strokes.

***Note:** Throughout the book, "lead" means a metal drafting holder with removeable lead; "pencil" refers to a wooden pencil.

PENCIL POINTS

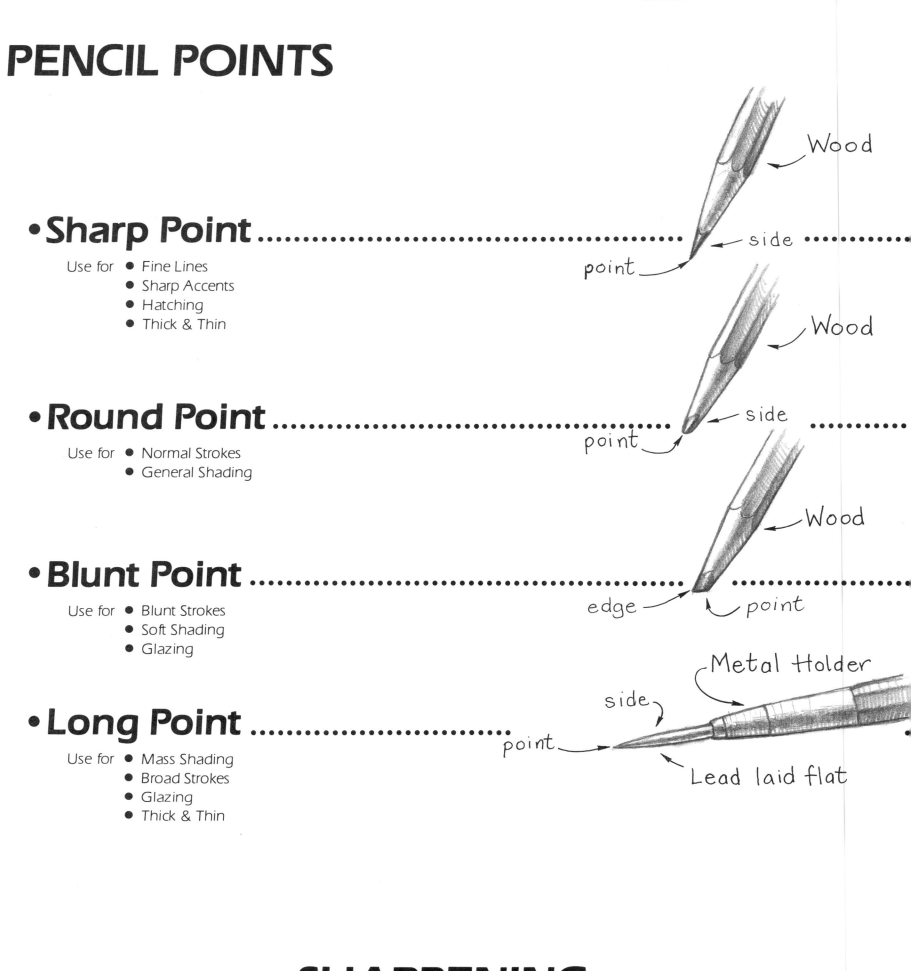

• Sharp Point

Use for
- Fine Lines
- Sharp Accents
- Hatching
- Thick & Thin

Wood

side

point

• Round Point

Use for
- Normal Strokes
- General Shading

Wood

side

point

• Blunt Point

Use for
- Blunt Strokes
- Soft Shading
- Glazing

Wood

edge

point

• Long Point

Use for
- Mass Shading
- Broad Strokes
- Glazing
- Thick & Thin

Metal Holder

side

point

Lead laid flat

SHARPENING

Wooden Pencil

You may use either an electric or manual sharpener for wooden pencils. After sharpening, rub the point on a paper towel to clean and smooth. The ball and blunt points are produced by brief use. While working, I keep several pencils with each type of point close at hand.

Metal Holder With Removable Leads

With about ½" of lead extended, I form the point on #240 sandpaper, then finish and polish it with #600 sandpaper to a long point as shown above.

PENCIL STROKES

| On Point | Side of Point | Laid Flat |

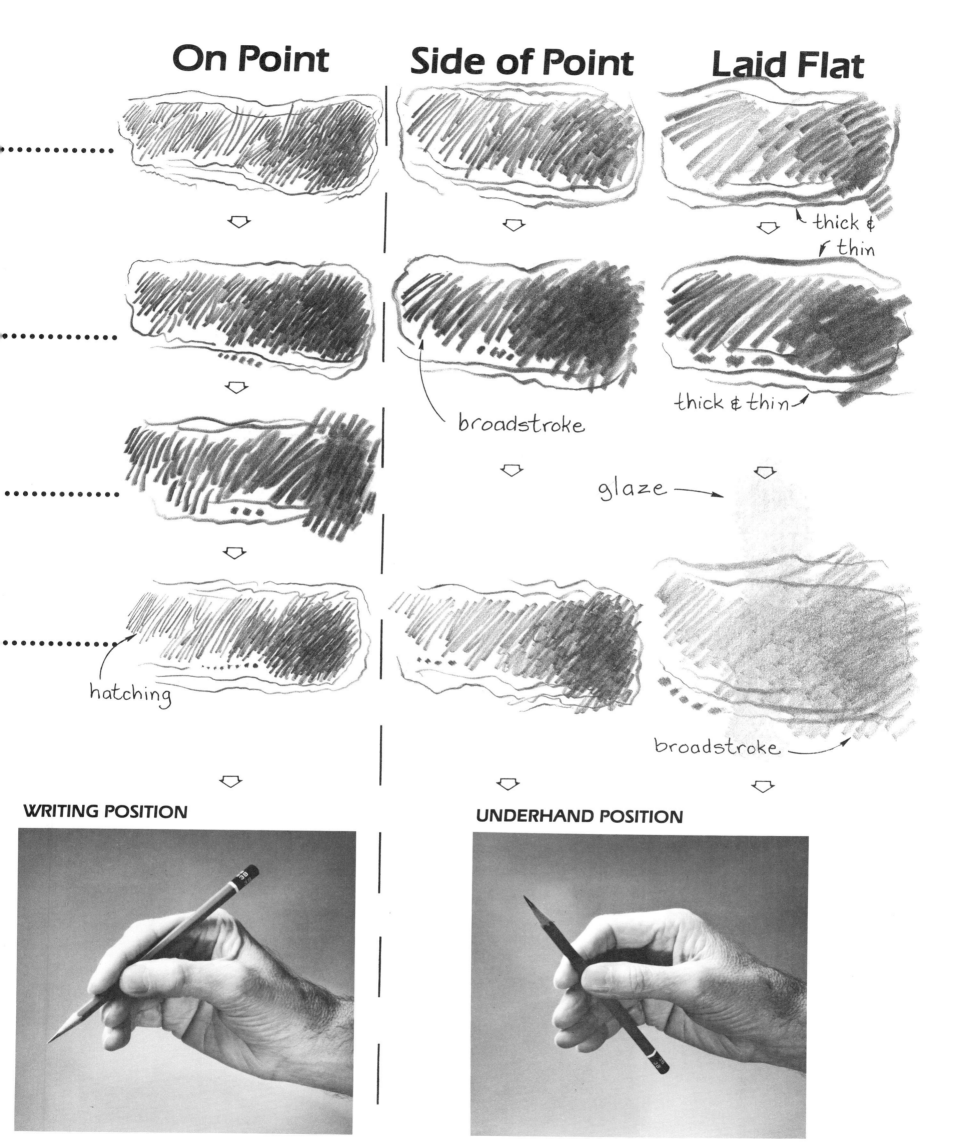

thick & thin

thick & thin

broadstroke

glaze

hatching

broadstroke

WRITING POSITION

UNDERHAND POSITION

VALUE SCALE

Tones

1.

Light

2.

Medium Light

3.
Medium

4.

Medium Dark

5.

Dark

Transition of Tone

H F HB B 3B 5B

Graduation of tones is accomplished by overlapping strokes with each hardness of lead.

 Shown here are five of the nine tones in the value scale. These five are all you will really need, even for advanced drawing. Practice these five tones as a musician might practice the musical scale — over and over. When the tones are firmly planted in your mind, you will be able to achieve the most refined shading effects. When you know instinctively how to hold and handle each pencil, you will be able to execute each tone with assurance.

 As you gradually master the value scale you will increasingly possess the ability to turn ordinary drawings into works of great substance and depth.

SHADING SAMPLES

Direct Light

Roundness

Reflected Light

Reflected Light

Show Roundness

Use both hand positions and all the point modes to practice shading these shapes. Explore how the different pencil points can yield varying tones from light to dark. Master using a sharp pencil to execute line work by rolling the point to create thicker and thinner lines. Use a round point on the side for soft strokes; a blunt one for soft, mass tone shading; and a long point for long broad strokes making separate wide lines or solid tones. Practice shading until your hand-mind communication becomes automatic. You can directly apply the experience you gain in shading practice to all your drawings.

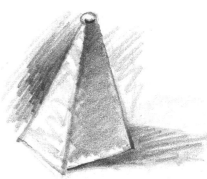

SKETCHING
TOWN...

WHY SKETCH?

Sketching is a shorthand form of drawing. This quick and easy way of getting ideas down on paper is an important part of the training program for art students.

The benefits received from this basic practice are numerous. Sketching develops your mind's eye, and hand coordination. It is a way of making a clearer visual study of the things around you. The sketches can be used as study ideas for finished paintings or drawings. As you form the habit of sketching, you will have fun and be rewarded in other ways, too. You will be programmed as a learned draftsman — a necessary element in becoming a truly competent artist. It is a fulfilling experience to be able to draw what you see!

...COUNTRY

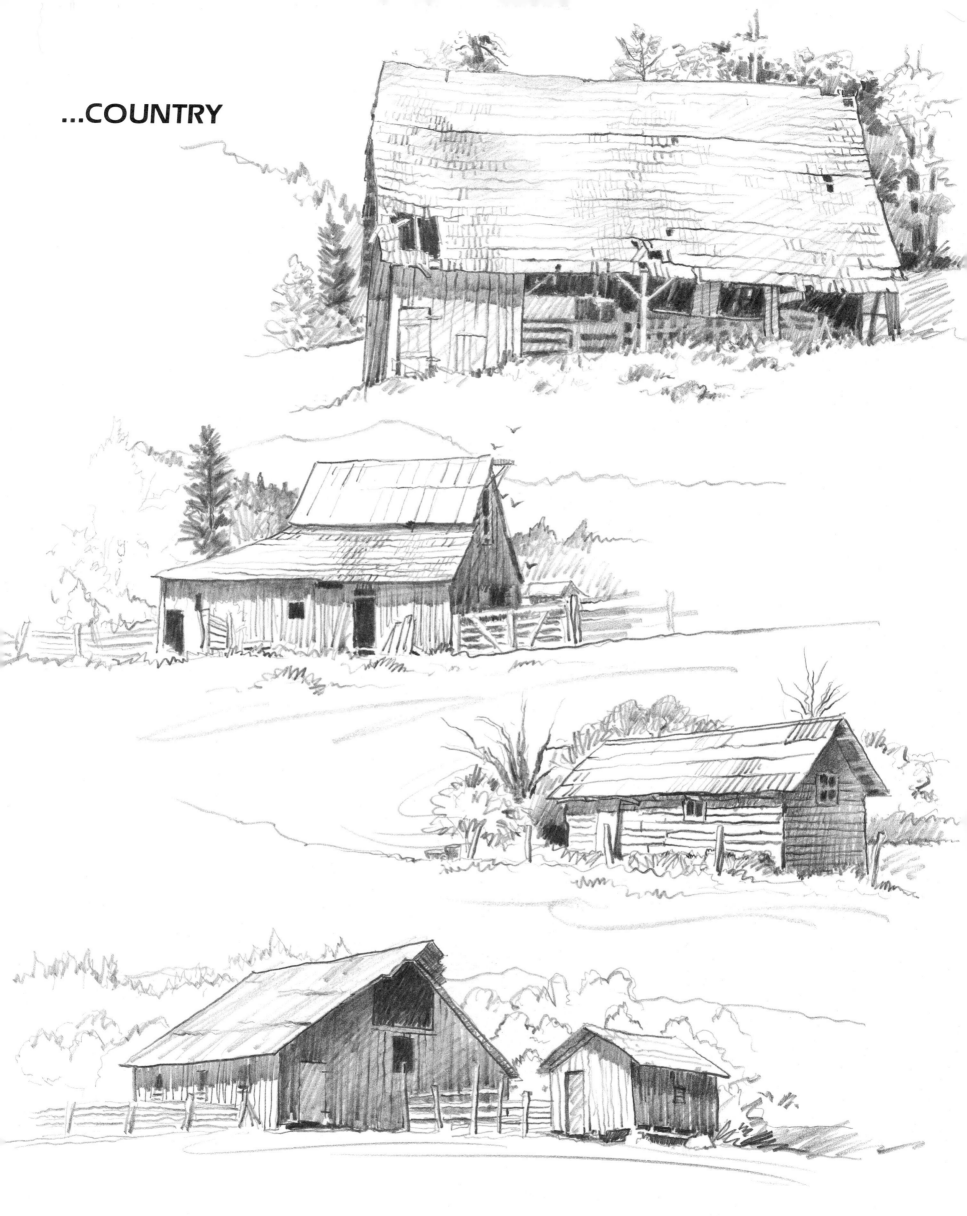

These fun sketches were done with B pencil, and 3B for final darks.

OREGON BARN

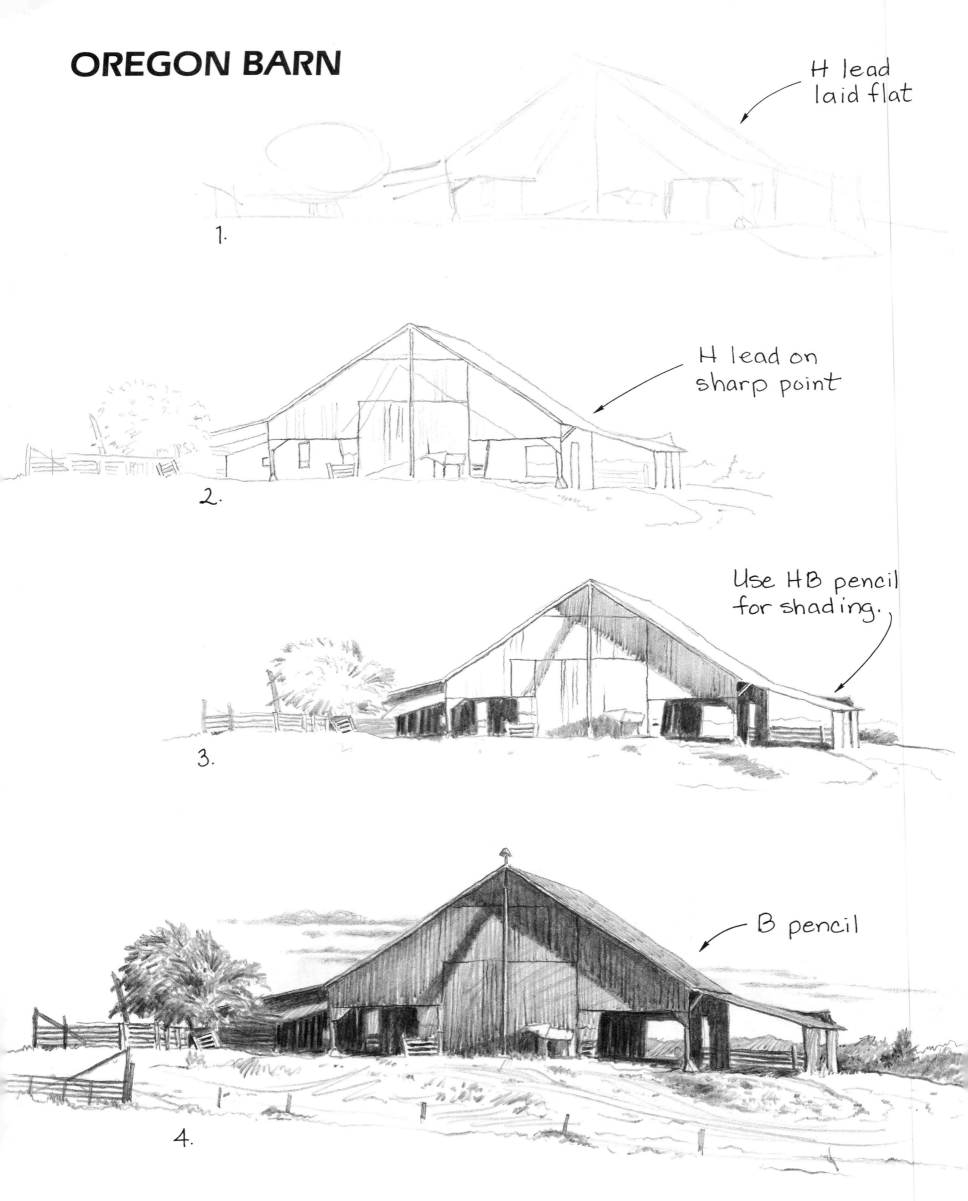

H lead
laid flat

1.

H lead on
sharp point

2.

Use HB pencil
for shading.

3.

B pencil

4.

Complete the final darks with your B pencils in the blunt and sharp point modes.

FARM HOUSE

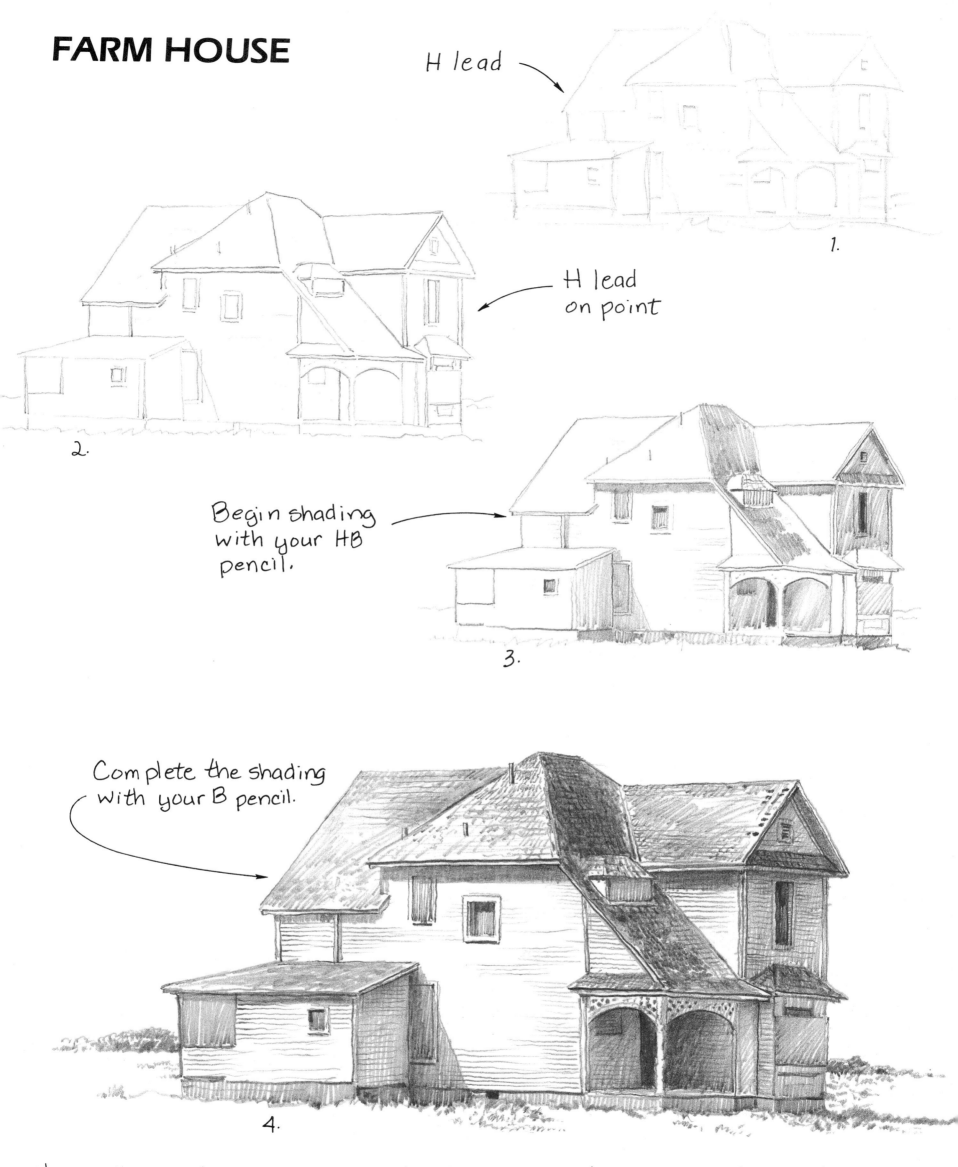

H lead

H lead
on point

Begin shading
with your HB
pencil.

Complete the shading
with your B pencil.

1.

2.

3.

4.

This interestingly-shaped and well-lit building is handled in a bold and simple
drawing technique.

ROOT CELLAR

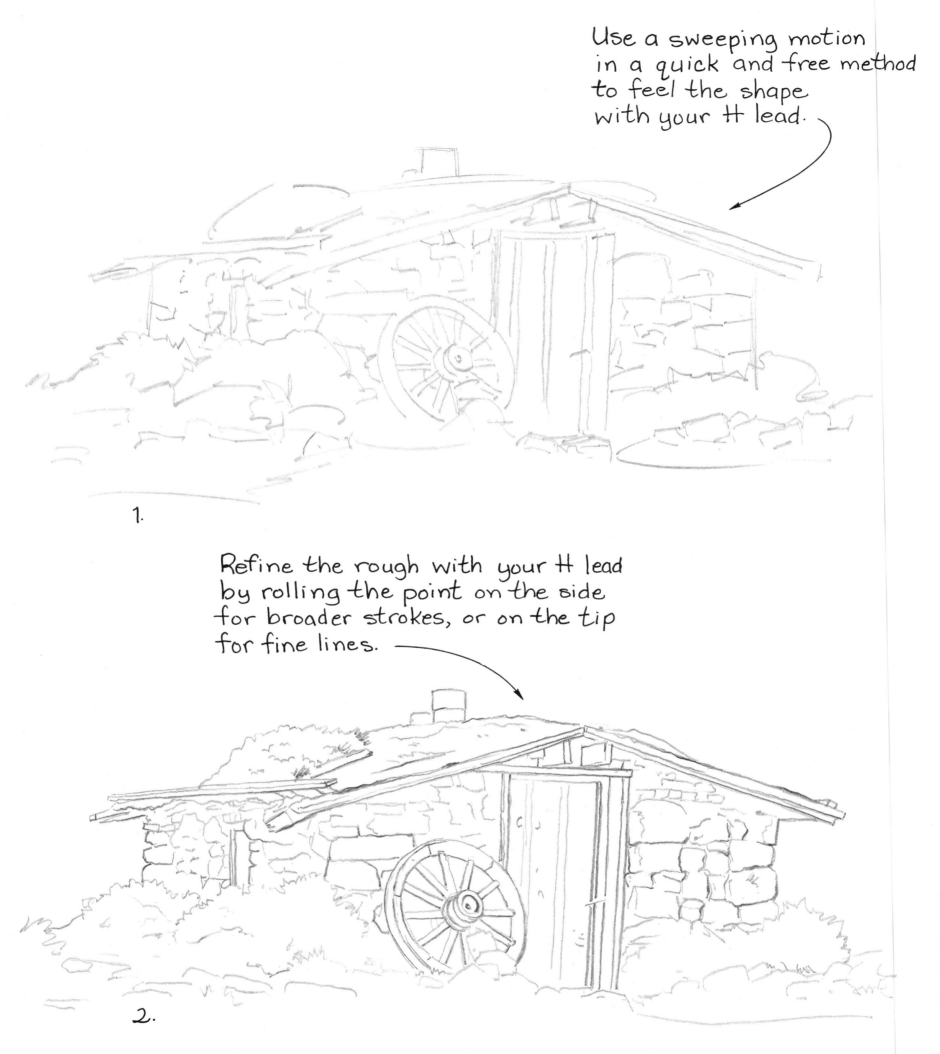

Use a sweeping motion in a quick and free method to feel the shape with your H lead.

1.

Refine the rough with your H lead by rolling the point on the side for broader strokes, or on the tip for fine lines.

2.

Observe carefully as you study the steps, and apply information learned to your finished drawing.

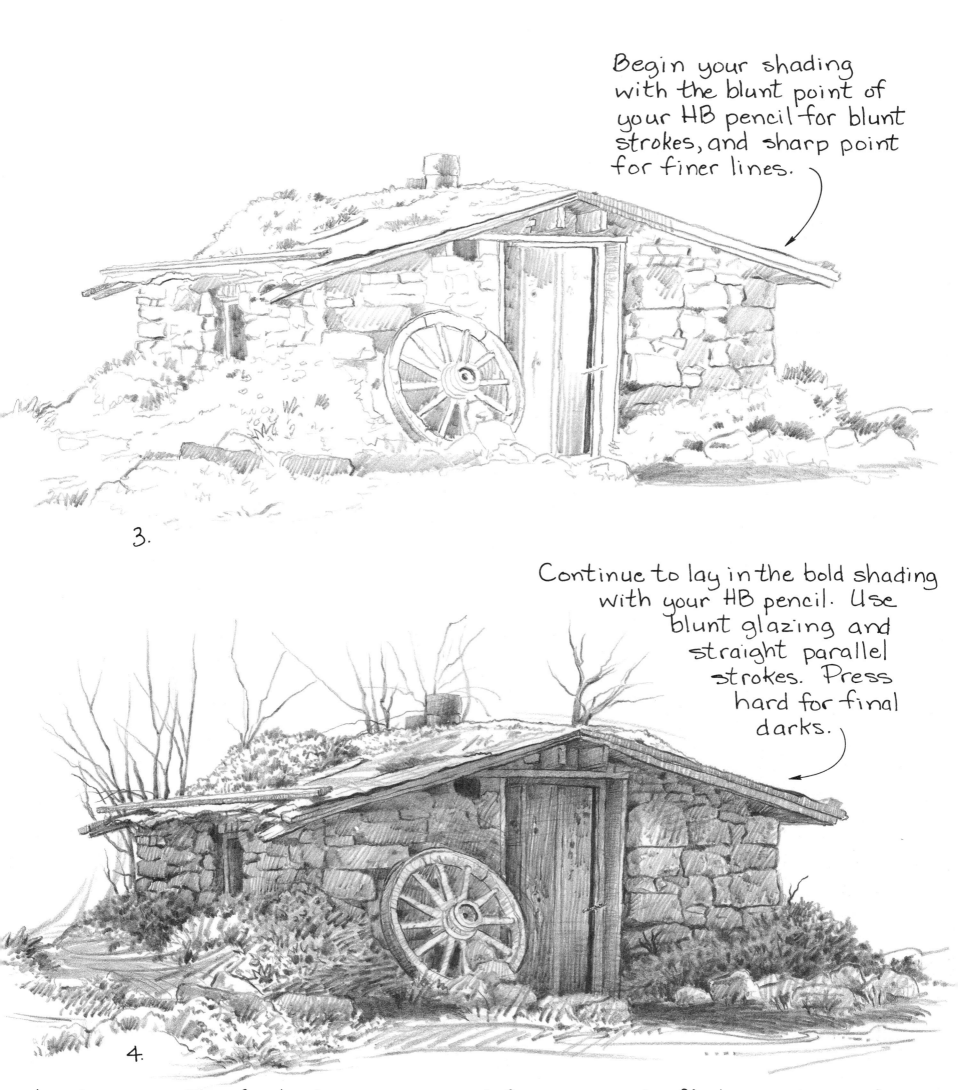

Begin your shading
with the blunt point of
your HB pencil for blunt
strokes, and sharp point
for finer lines.

3.

Continue to lay in the bold shading
with your HB pencil. Use
blunt glazing and
straight parallel
strokes. Press
hard for final
darks.

4.

The trees in the final step were added for a special effect and to create
variety of design.

COUNTRY CHURCH

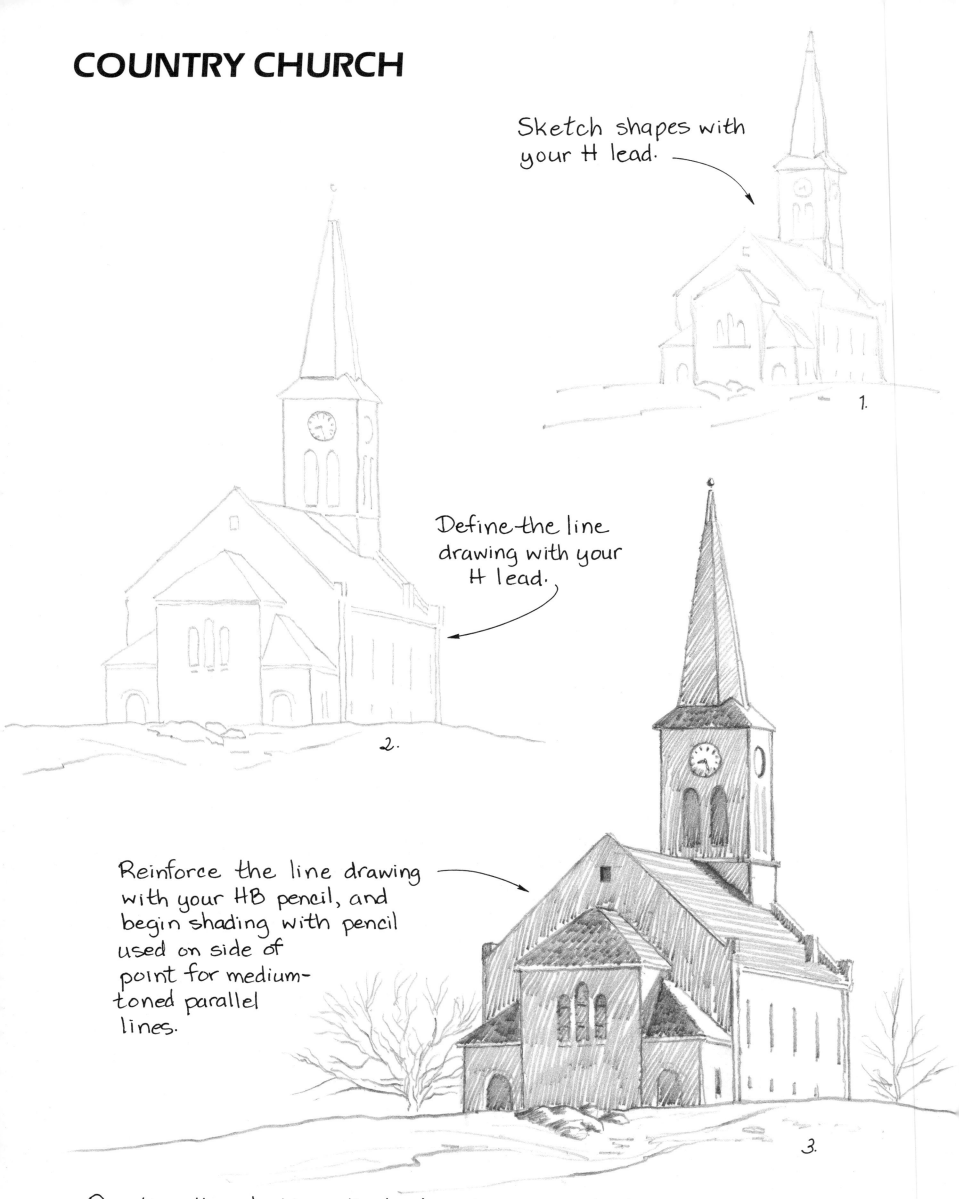

Sketch shapes with your H lead.

1.

Define the line drawing with your H lead.

2.

Reinforce the line drawing with your HB pencil, and begin shading with pencil used on side of point for medium-toned parallel lines.

3.

Practice this bold method of preliminary shading in your own work.

Use strong darks against light
areas for dramatic contrast
as demonstrated here.

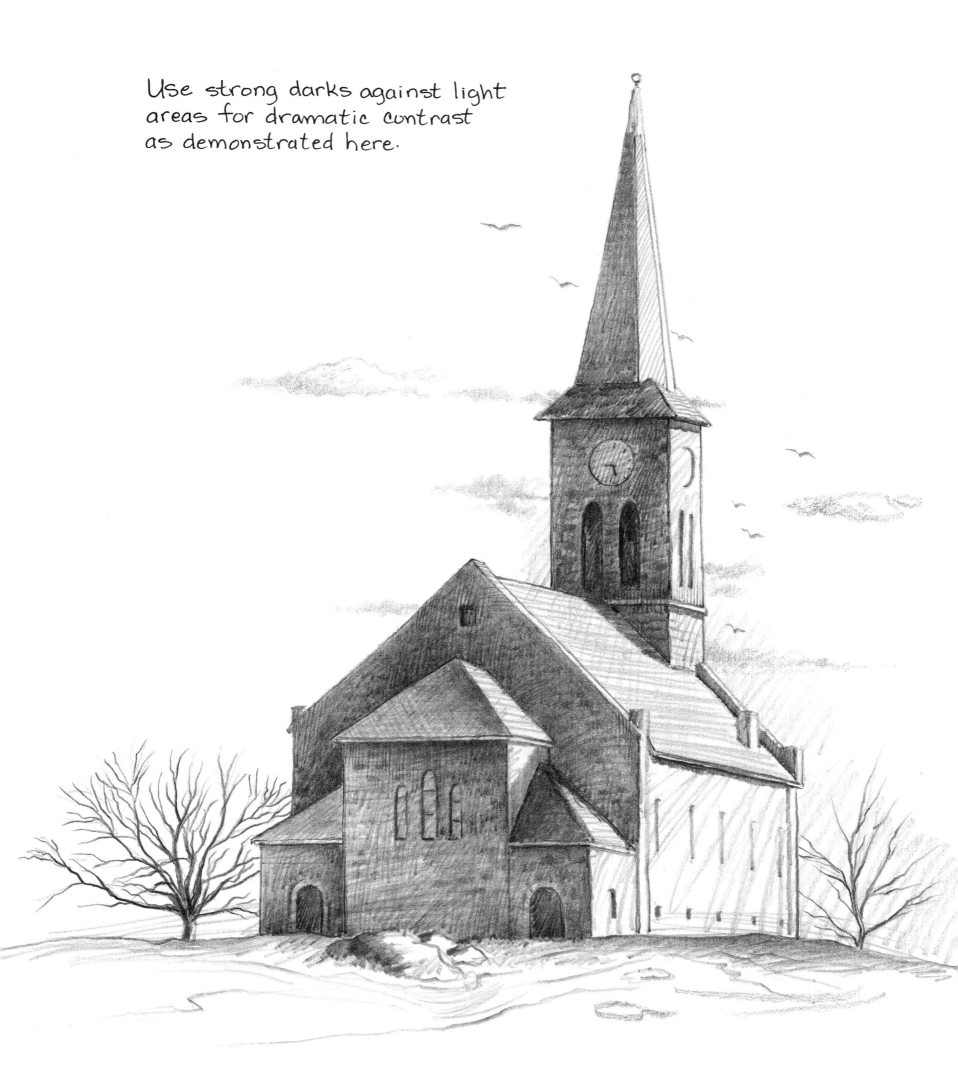

Establish shadows with the HB pencil, then come on with your B pencil used
on blunt and round points — pressing hard for dark contrasting tones and
accented lines. Your 3B pencil may be needed for final blacks.

WINDMILL

Feel the design and shape of the windmill with your H lead laid flat.

1.

Execute line drawing with your HB pencil on the point.

Begin preliminary shading over the established line with your B pencil on sharp and blunt points. Reinforce dark accents as the tones develop.

In the final step, next page, press hard with 3B pencil on round and blunt points for final shading and deepest blacks.

2. & 3.

This simple instruction will show you how to get started.

The background is rendered with your B blunt points pressed hard for broad expressive strokes.

4.

This inspiring subject was found in a Danish community.

ENGLISH COTTAGE

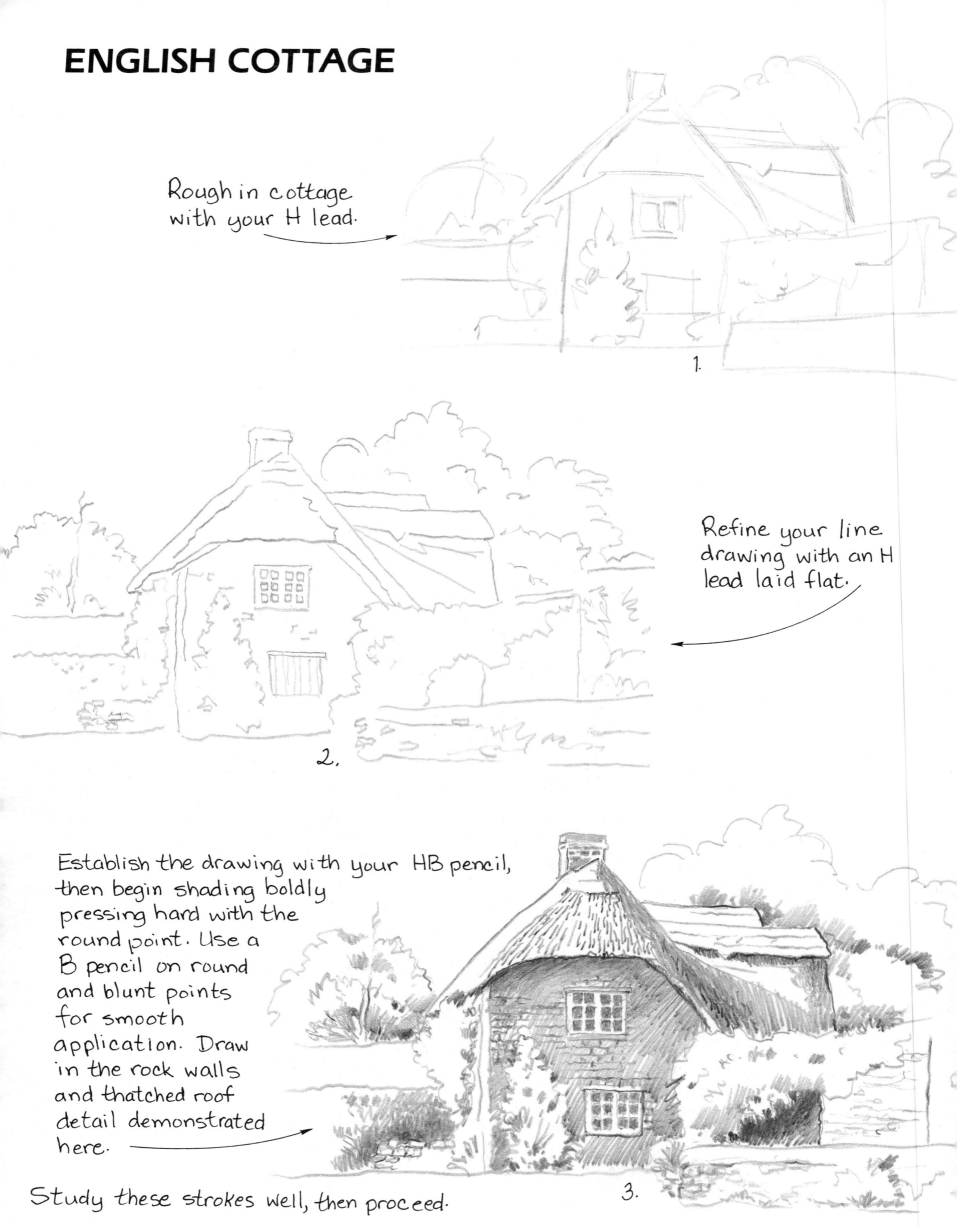

Rough in cottage with your H lead. → 1.

Refine your line drawing with an H lead laid flat. ← 2.

Establish the drawing with your HB pencil, then begin shading boldly pressing hard with the round point. Use a B pencil on round and blunt points for smooth application. Draw in the rock walls and thatched roof detail demonstrated here. → 3.

Study these strokes well, then proceed.

You will enjoy the many blessings of pencil drawing after firmly planting in your mind the basic handling procedure. Experiment with all the point modes for your own personal effects. Hold the pencil in various positions until you find which is most comfortable for you. Learn to see the values in each piece of work, and approach each subject with assured vigor to obtain boldness, as shown here.

4.

Experiment pressing hard with your round and blunt points for detail and texture while hatching and glazing.

CLIFF DWELLING

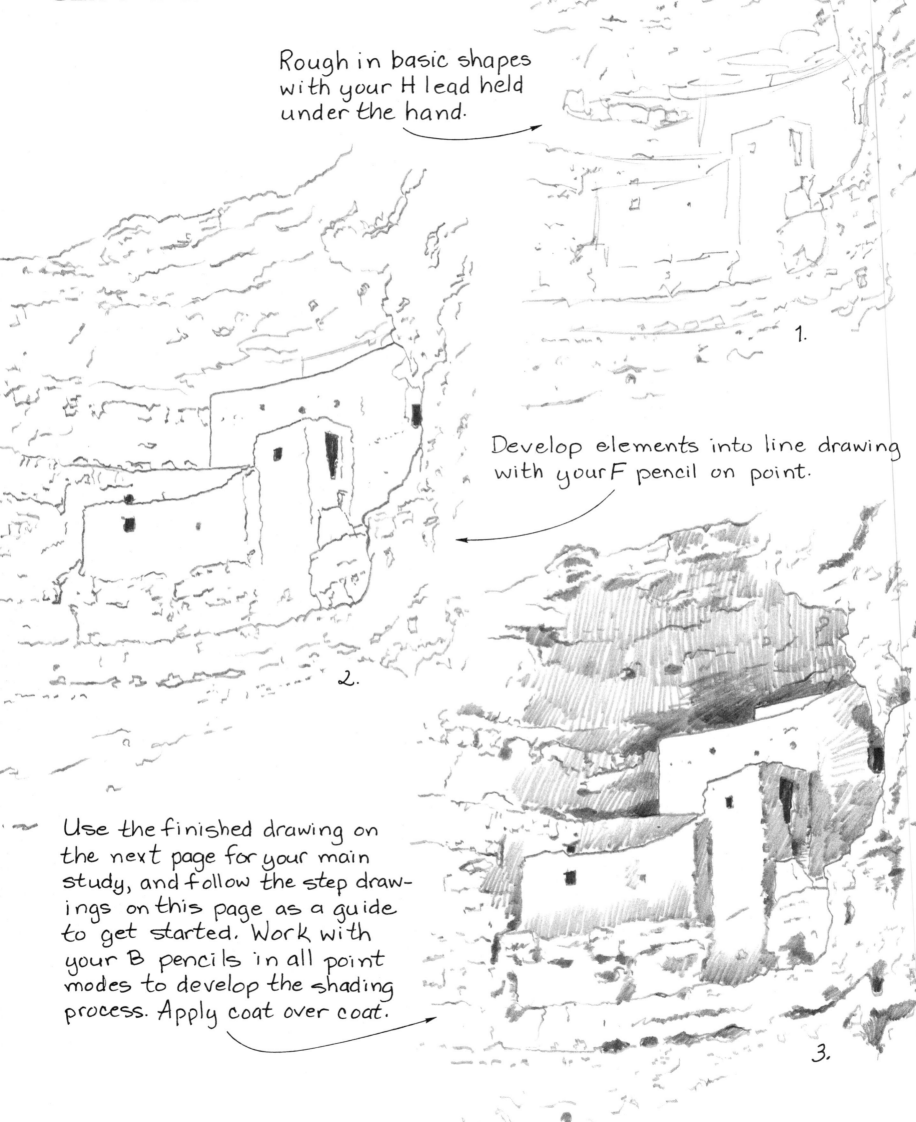

Rough in basic shapes with your H lead held under the hand.

1.

Develop elements into line drawing with your F pencil on point.

2.

Use the finished drawing on the next page for your main study, and follow the step drawings on this page as a guide to get started. Work with your B pencils in all point modes to develop the shading process. Apply coat over coat.

3.

4.

The challenge of this great subject is to create a wide variety of grays with limited dark accents. Shading is accomplished with the B pencil only. Press hard with round point for separate strokes, as in hatching. Glaze over and over with blunt point for smooth application. Multi-coating gives depth and a chiseled-out effect.

SPANISH MISSION

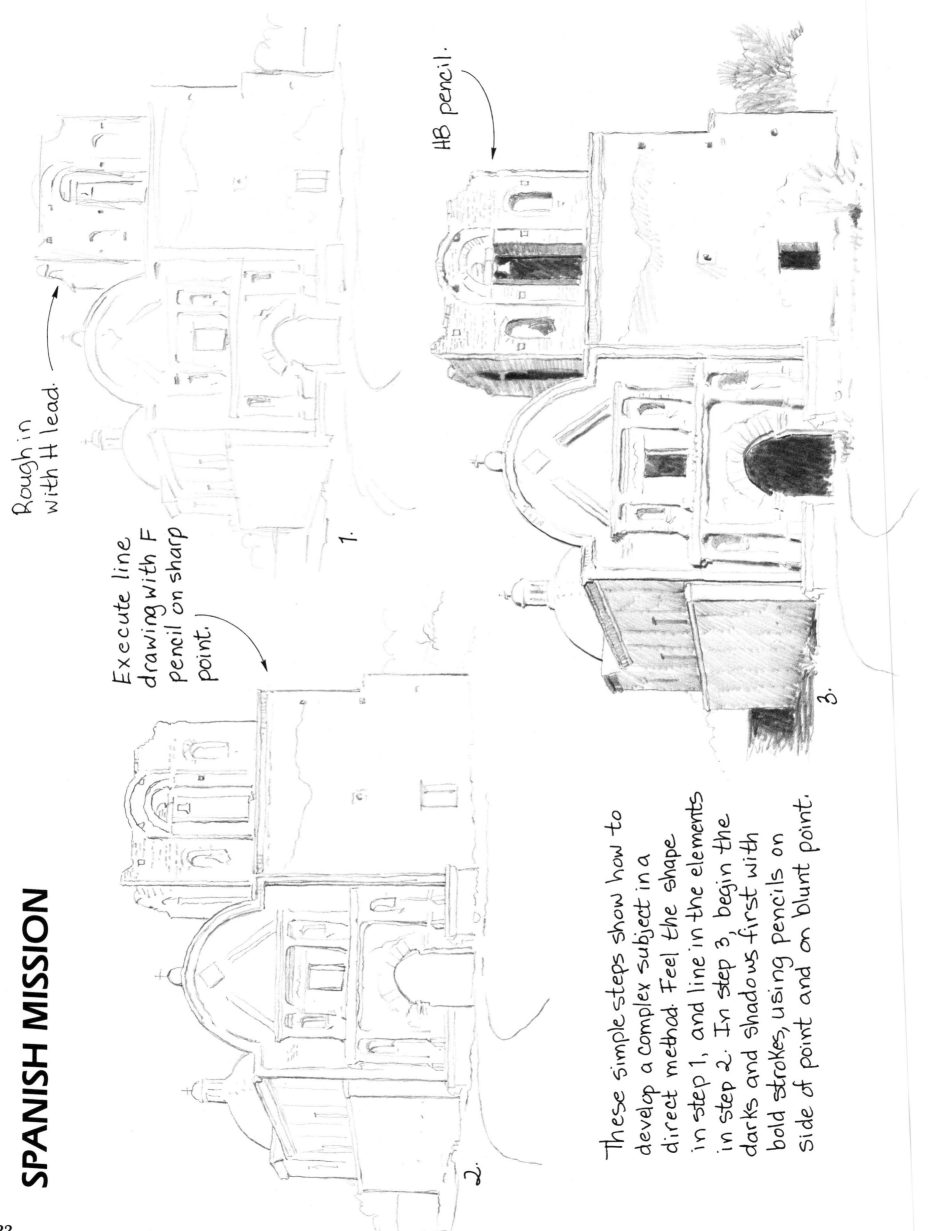

Rough in with H lead.

1.

Execute line drawing with F pencil on sharp point.

2.

HB pencil.

3.

These simple steps show how to develop a complex subject in a direct method. Feel the shape in step 1, and line in the elements in step 2. In step 3, begin the darks and shadows first with bold strokes, using pencils on side of point and on blunt point.

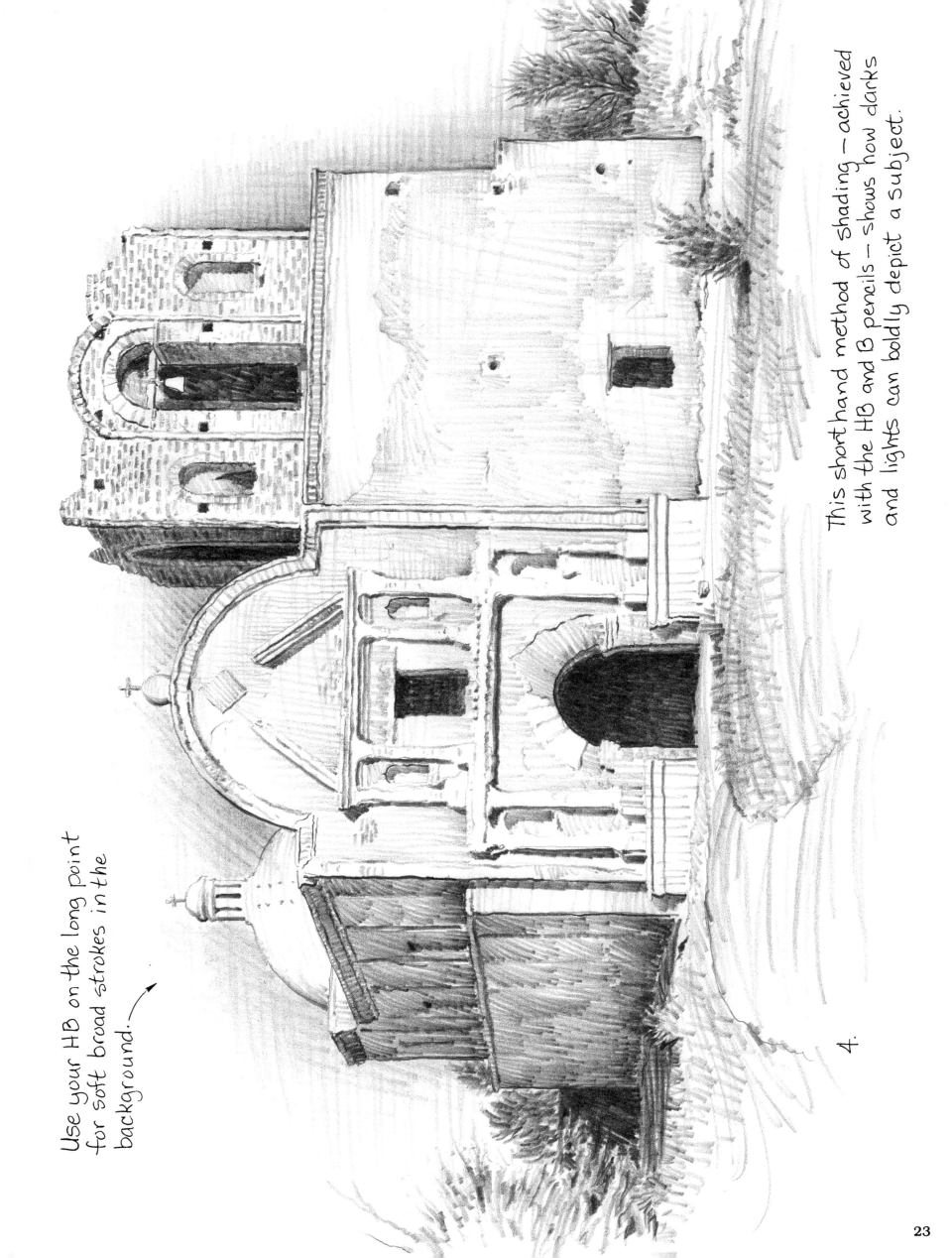

Use your HB on the long point for soft broad strokes in the background.

This short hand method of shading — achieved with the HB and B pencils — shows how darks and lights can boldly depict a subject.

4.

LIGHTHOUSE

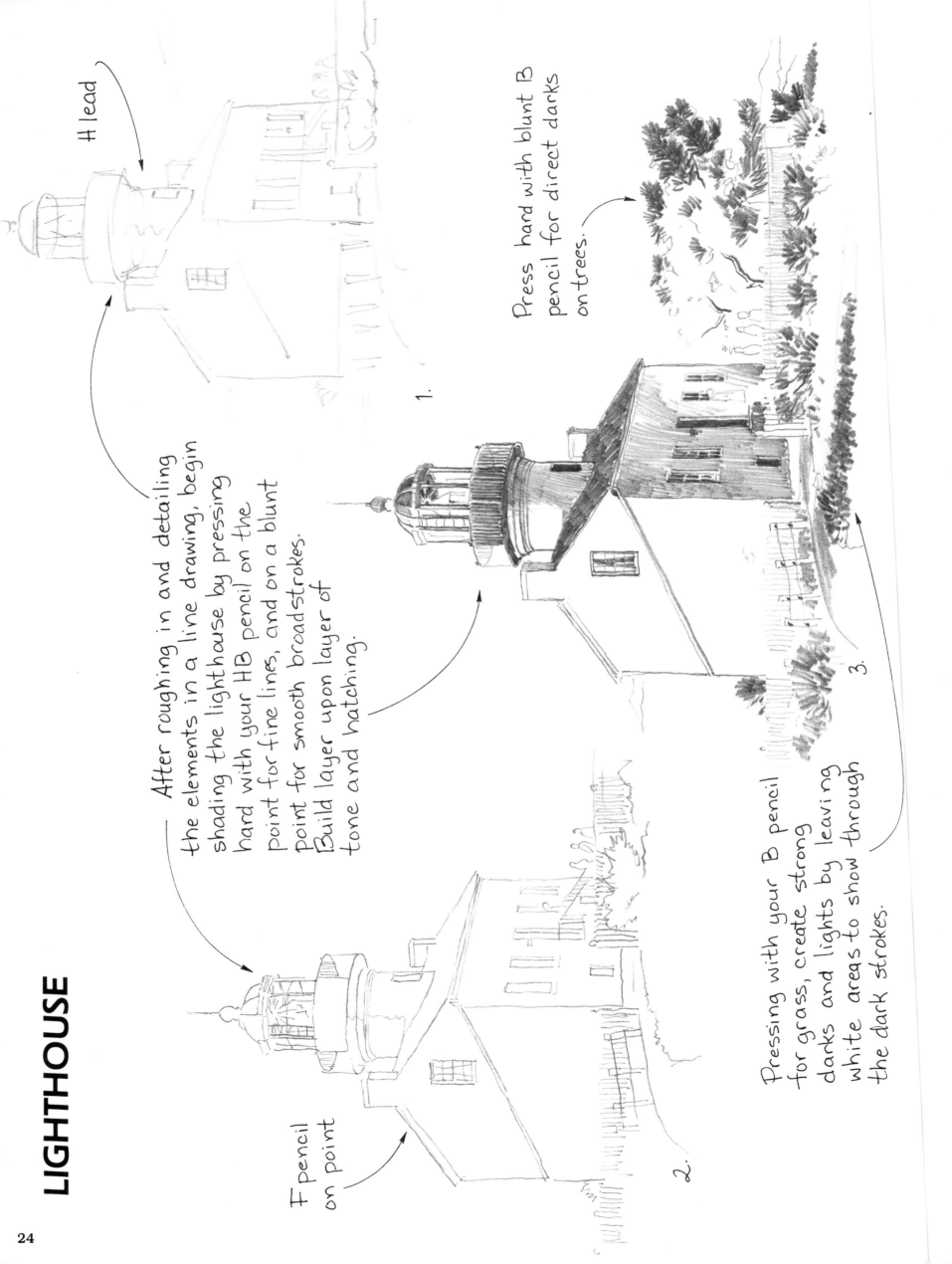

H lead

Press hard with blunt B pencil for direct darks on trees.

After roughing in and detailing the elements in a line drawing, begin shading the lighthouse by pressing hard with your HB pencil on the point for fine lines, and on a blunt point for smooth broadstrokes. Build layer upon layer of tone and hatching.

F pencil on point

Pressing with your B pencil for grass, create strong darks and lights by leaving white areas to show through the dark strokes.

1.

2.

3.

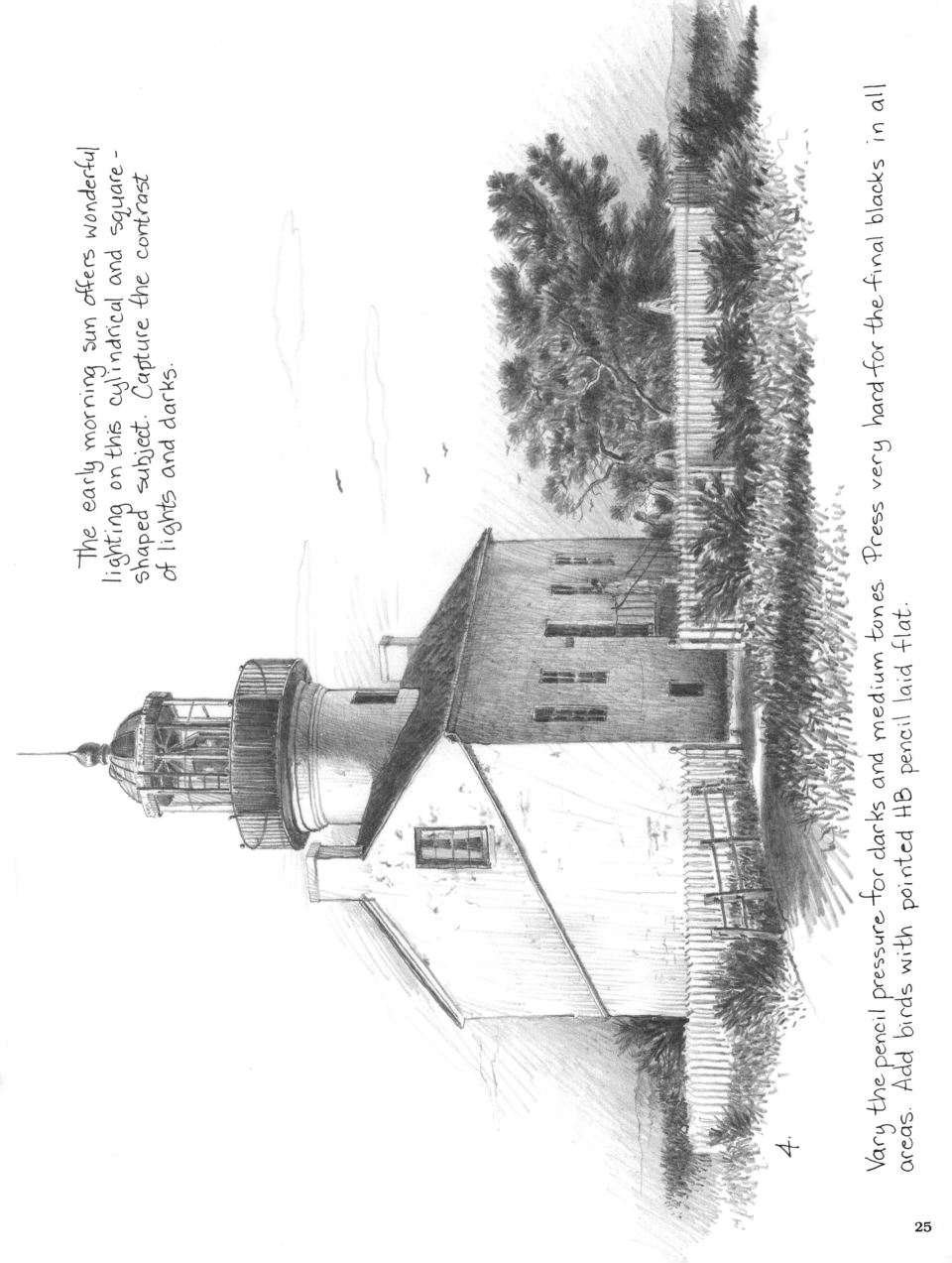

The early morning sun offers wonderful lighting on this cylindrical and square - shaped subject. Capture the contrast of lights and darks.

4.

Vary the pencil pressure for darks and medium tones. Press very hard for the final blacks in all areas. Add birds with pointed HB pencil laid flat.

SCHOOL HOUSE

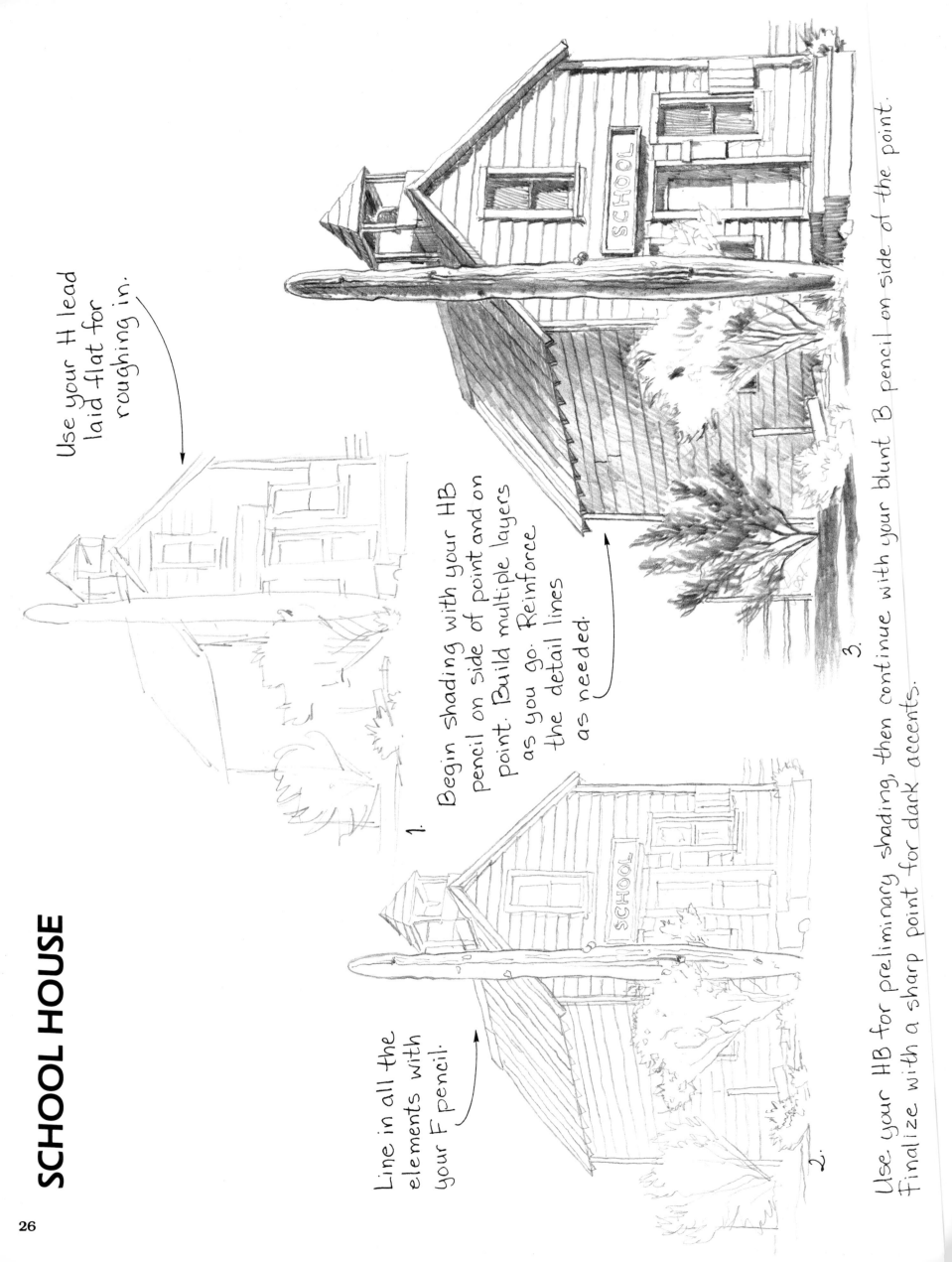

Use your H lead laid flat for roughing in.

Line in all the elements with your F pencil.

1. Begin shading with your HB pencil on side of point and on point. Build multiple layers as you go. Reinforce the detail lines as needed.

2. Use your HB for preliminary shading, then continue with your blunt B pencil on side of the point. Finalize with a sharp point for dark accents.

3.

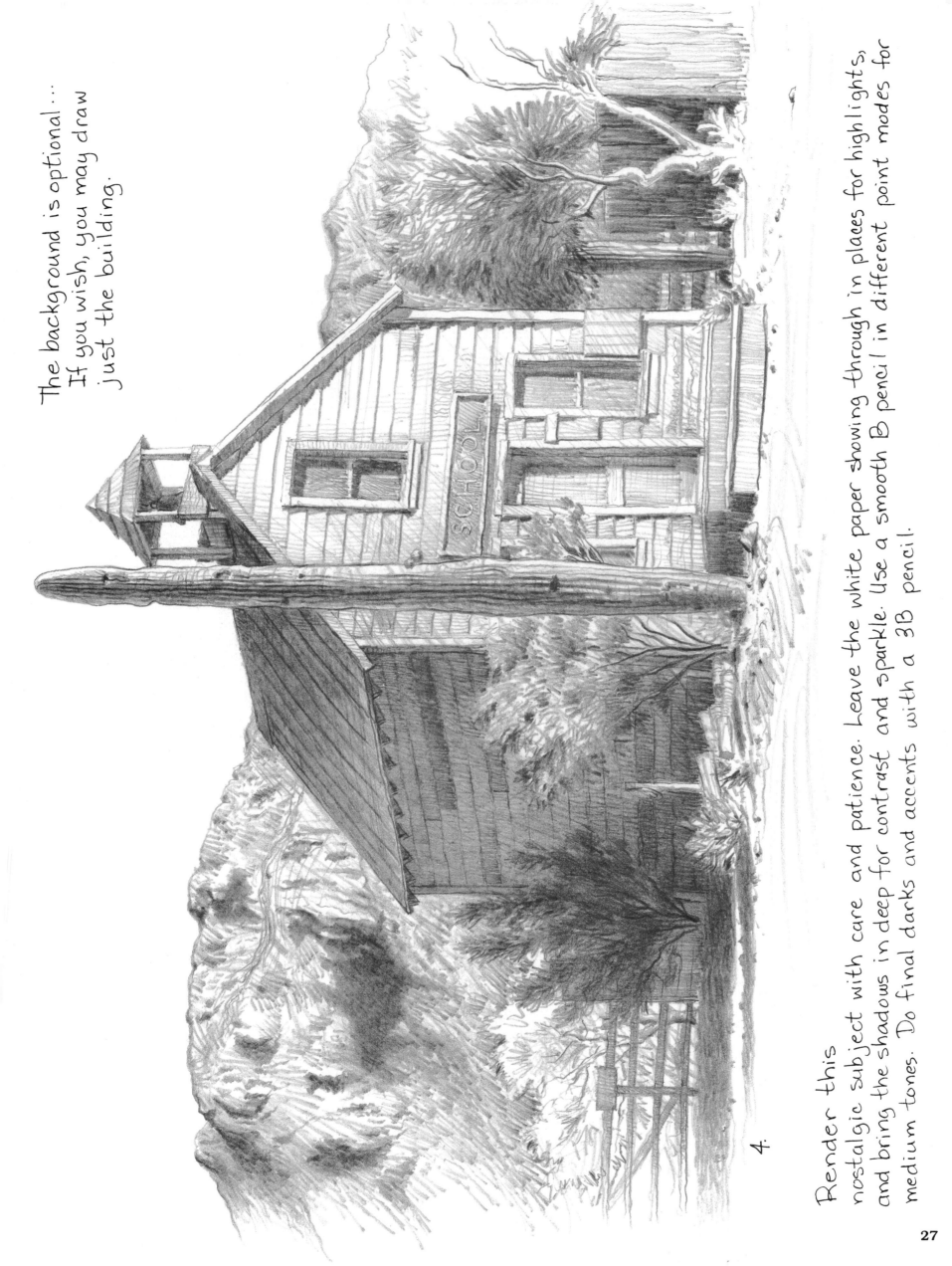

The background is optional ... If you wish, you may draw just the building.

Render this nostalgic subject with care and patience. Leave the white paper showing through in places for highlights, and bring the shadows in deep for contrast and sparkle. Use a smooth B pencil in different point modes for medium tones. Do final darks and accents with a 3B pencil.

4.

THE CANTINA

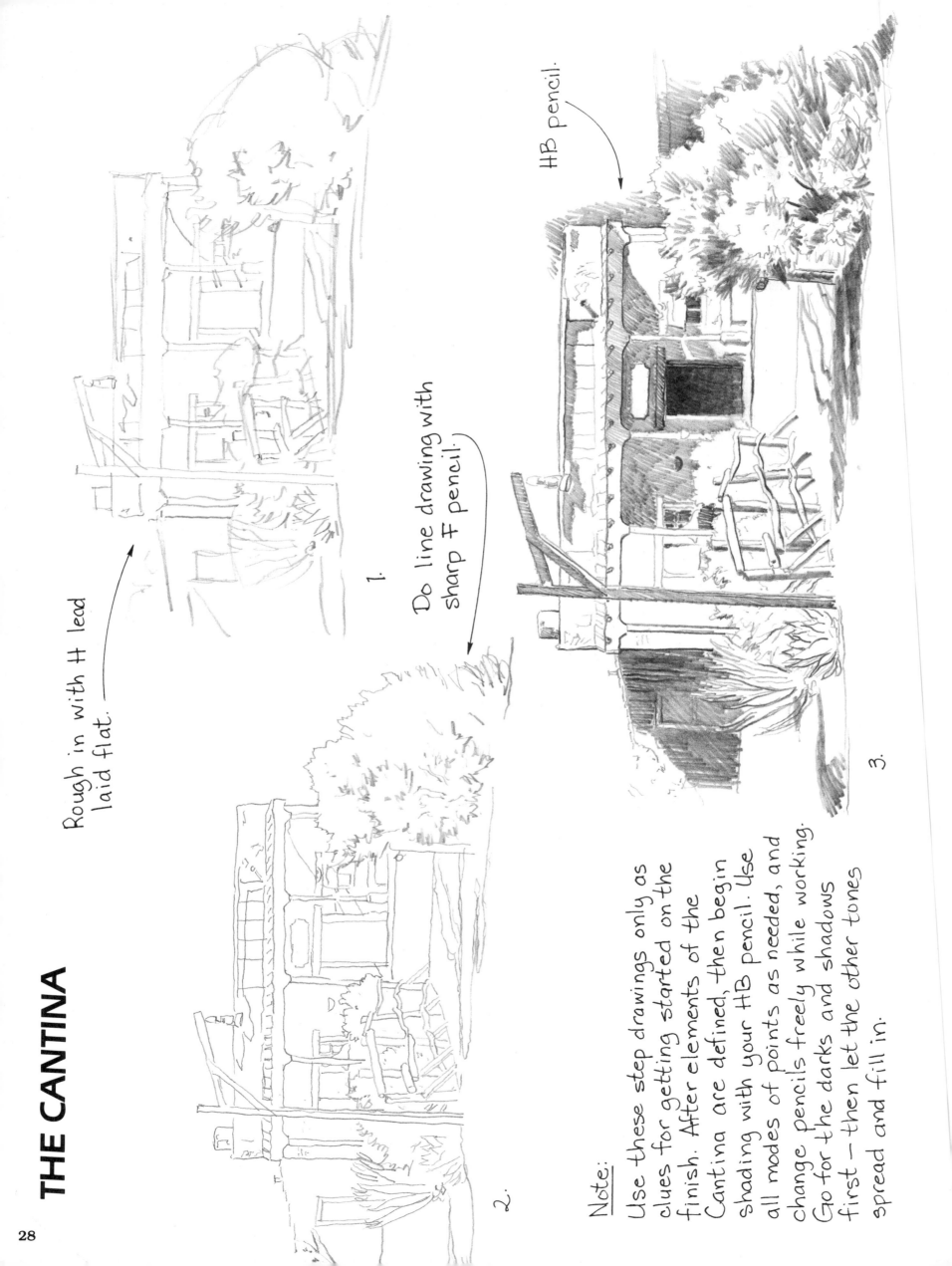

Rough in with H lead
laid flat.

1.

Do line drawing with
sharp F pencil.

2.

HB pencil.

3.

Note:

Use these step drawings only as
clues for getting started on the
finish. After elements of the
Cantina are defined, then begin
shading with your HB pencil. Use
all modes of points as needed, and
change pencils freely while working.
Go for the darks and shadows
first – then let the other tones
spread and fill in.

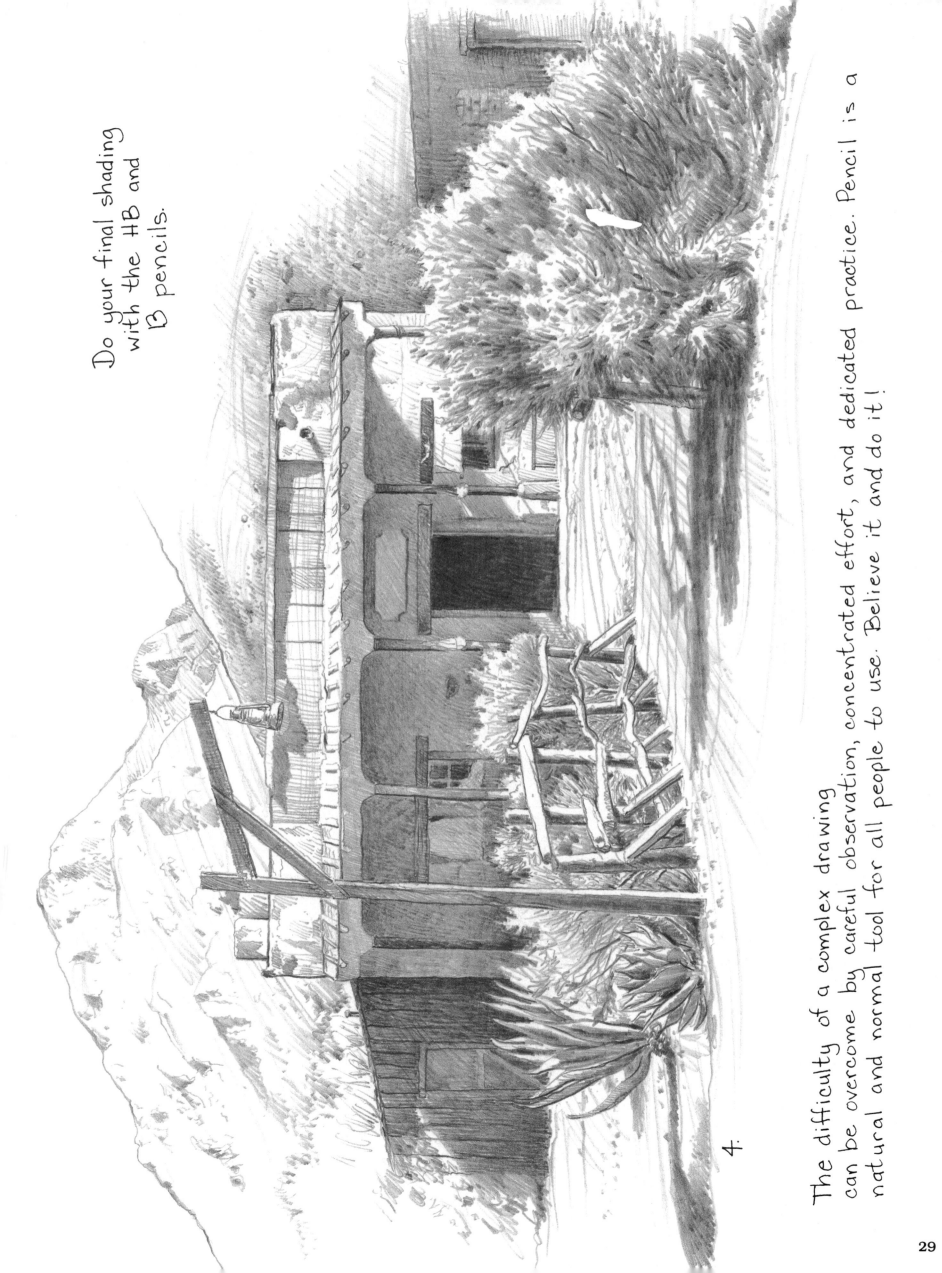

Do your final shading with the #B and B pencils.

4.

The difficulty of a complex drawing can be overcome by careful observation, concentrated effort, and dedicated practice. Pencil is a natural and normal tool for all people to use. Believe it and do it!

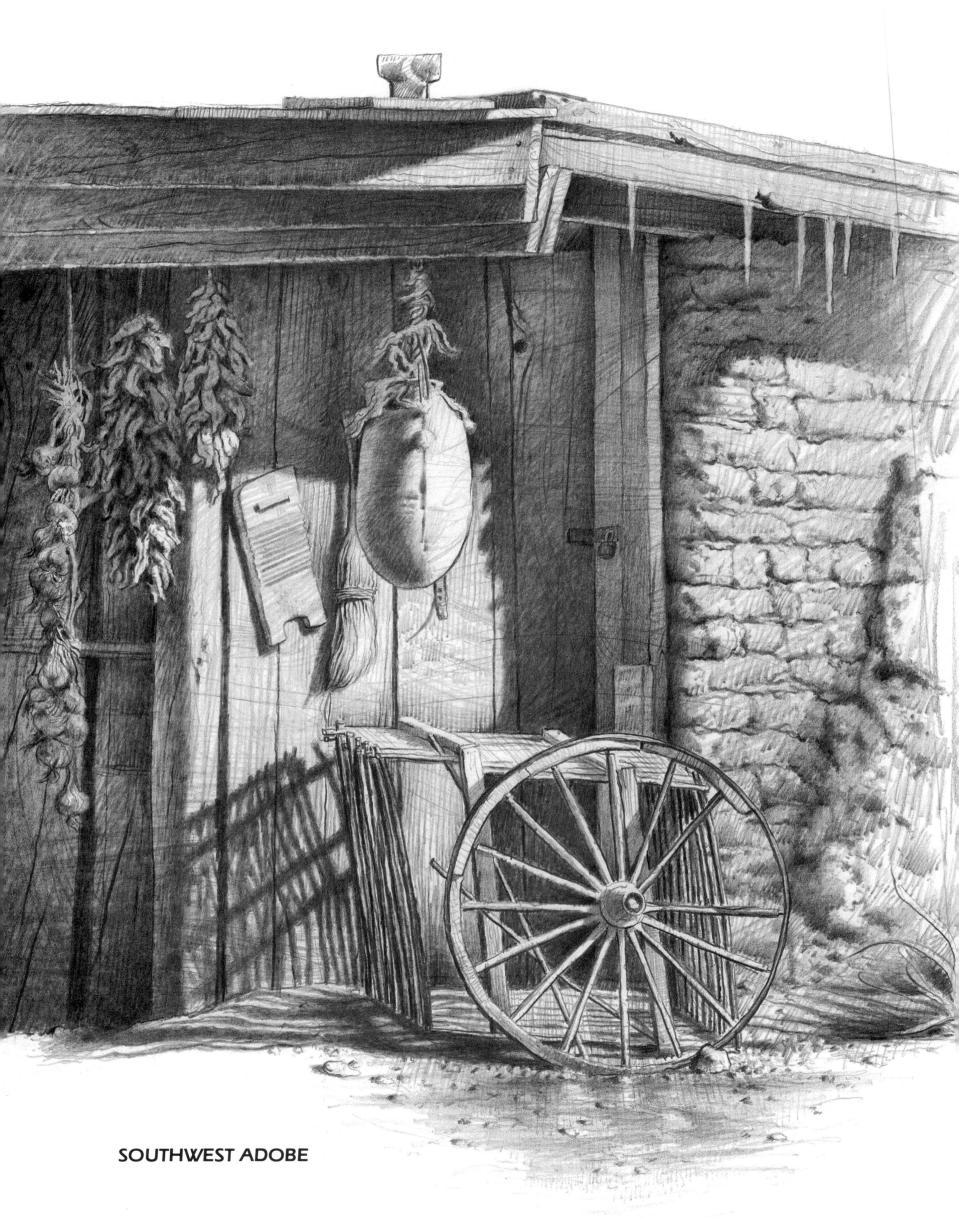

SOUTHWEST ADOBE

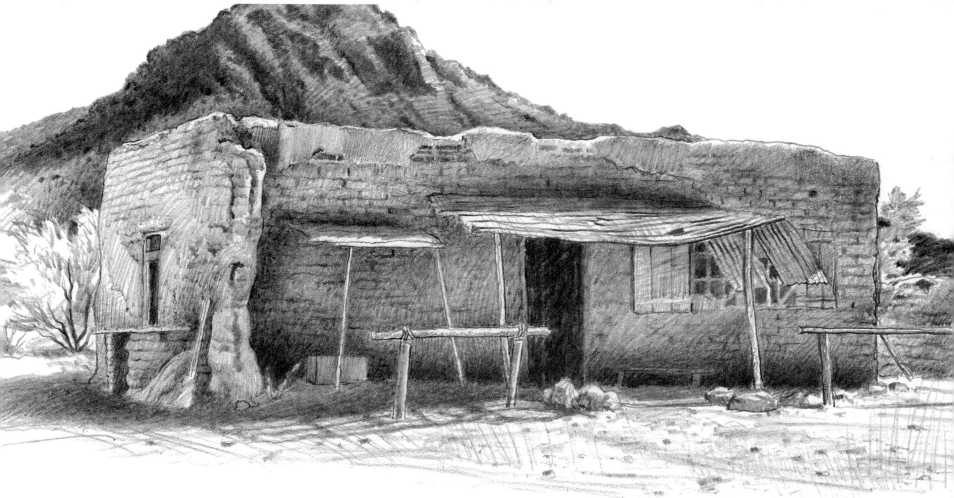

John Wayne House
Old Tucson

GLOSSARY

BROADSTROKE — A stroke created by laying a long point of lead or pencil on the side.

GLAZE — A transparent film of tone, laid in over other strokes; accomplished with a sharp lead or pencil laid flat or with a blunt lead on the point.

HARD EDGE — A crisp outline which makes the subject appear to come forward; produced with a sharp pencil; effective for accents and underlining.

LINE DRAWING — Outlining the features of an object; produced by varying the pressure on a sharp point and on the side of a point.

MASS TONE — The shading of large areas in a broad back and forth motion, achieved with a sharp lead or pencil laid flat or a blunt lead on point.

MAULSTICK — A long, light stick to steady the hand and prevent smudging.

PENCIL POINT MODE — Degree of sharpness.

PENCIL PRESSURE — The personalized degree of firmness in application of pencil that makes your style your own.

ROUGHING IN — Sketching shapes in their simplest form.

SHADING — Applying multiple layers of tones with pencil strokes and glazing.

SKETCH — A simple study of lights and darks, with little detail and accented with "line drawing" (see above).

SOFT EDGE — An indistinct outline which makes the subject appear to recede; produced with a blunt pencil or lead; effective for showing roundness and depth.

SOFT STROKES — A series of short lines made with a blunt point.

THICK & THIN LINES — Variable widths of line drawing (Step 2 of "Pencil Procedure"); executed by varying pressure on the point and/or by rolling on the side of the lead or pencil.

TONE — The application of a "value" (see below).

TRANSITION — A blending of tone from light to dark.

VALUE — The degree of lightness or darkness. There are nine values in the value scale.

WORKABLE FIXATIVE — A resin solution, available in a spray can, used to "fix" the finished drawing to the paper in order to prevent smudging.

Walter Foster Art Instruction Program

THREE EASY STEPS TO LEARNING ART

Beginner's Guides are specially written to encourage and motivate aspiring artists. This series introduces the various painting and drawing media—acrylic, oil, pastel, pencil, and watercolor—making it the perfect starting point for beginners. Book One introduces the medium, showing some of its diverse possibilities through beautiful rendered examples and simple explanations, and Book Two instructs with a set of engaging art lessons that follow an easy step-by-step approach.

How to Draw and Paint titles contain progressive visual demonstrations, expert advice, and simple written explanations that assist novice artists through the next stages of learning. In this series, professional artists tap into their experience to walk the reader through the artistic process step by step, from preparation work and preliminary sketches to special techniques and final details. Organized by medium, these books provide insight into an array of subjects.

Artist's Library titles offer both beginning and advanced artists the opportunity to expand their creativity, conquer technical obstacles, and explore new media. Written and illustrated by professional artists, the books in this series are ideal for anyone aspiring to reach a new level of expertise. They'll serve as useful tools that artists of all skill levels can refer to again and again.

Walter Foster products are available at art and craft stores everywhere.

Write or call for a FREE catalog that includes all of Walter Foster's titles, or visit our website at www.walterfoster.com.

WALTER FOSTER PUBLISHING, INC.
23062 La Cadena Drive
Laguna Hills, California 92653
Main Line 949/380-7510
Toll Free 800/426-0099

www.walterfoster.com